IMAGES
of America

KANKAKEE
1911–1953

Kankakee entered the second decade of the 20th century full of optimism. The city of Kankakee, along with Kankakee County and its many towns and villages, had grown dramatically since its creation in 1853. The inhabitants of Kankakee throughout the next 40 years, from 1911 to 1953, would exude confidence in the continued viability of their community that is well illustrated by the photographs presented in this book. The continued sense of community so evident in Kankakee is symbolized with this photograph of a Labor Day Parade, marching down Kankakee's Court Street in September 1950. (KCMPC, P2641.)

IMAGES
of America

KANKAKEE
1911–1953

Norman Stevens and the
Kankakee County Historical Society

Copyright © 2005 by Norman Stevens and the Kankakee County Historical Society
ISBN 0-7385-3980-5

Published by Arcadia Publishing
Charleston SC, Chicago IL, Portsmouth NH, San Francisco CA

Printed in Great Britain

Library of Congress Catalog Card Number: 2005928931

For all general information contact Arcadia Publishing at:
Telephone 843-853-2070
Fax 843-853-0044
E-mail sales@arcadiapublishing.com
For customer service and orders:
Toll-Free 1-888-313-2665

Visit us on the Internet at http://www.arcadiapublishing.com

On the Cover: Dairymen of the Kankakee Pure Milk Company are seen here with some of their customers in this 1912 image. The Kankakee Pure Milk Company operated at Schuyler Avenue. (KCMPC, P3216.)

CONTENTS

Acknowledgments 6

Introduction 7
"We Face an Uncertain Future, Braced with Confidence in Our Past"

1. 1911 to 1916 9
The Last Decade of Innocence: "We Seem to Be Finding Ourselves"

2. 1917 to 1921 25
Kankakee and the Great War: "Making the Kaiser Dance"

3. 1922 to 1928 45
Starting Back to Normalcy: "There Seems to Be but Little Ballyhoo Here"

4. 1929 to 1934 59
The Great Depression: "We Are Not Quite Down and Out"

5. 1935 to 1939 77
The Great Depression: "People Are Managing to Survive This Thing"

6. 1940 to 1945 93
Kankakee and World War II: "Everyone Wants to Do Their Part"

7. 1946 to 1953 109
The Immediate Postwar Period: "A New Order of Things Prevail"

Acknowledgments

The photographs in this book (with two exceptions) all come from the voluminous photographic still collection of the Kankakee County Museum, which has been the home of the Kankakee County Historical Society since 1906. I have been the executive director of the Kankakee County Museum and the Kankakee County Historical Society since 2002. I have selected the photographs included, organized them, and written all associated text. Any omission or textual error is, therefore, my responsibility. I should like to thank the museum staff: Jane Van Ostrand, administrative assistant, for her outstanding ability to handle everyday museum operations. I also express my thanks to Loretta Mason and Robin La Voie for their daily general assistance. I should also like to thank the editor assigned to me by Arcadia Publishing, Ann Marie Lonsdale, for her assistance and patience. I particularly want to thank my wife Linda Stevens for her presence not only during the term of this project, but for always being there in the remainder of my life. Her daily impact is both positive and undeniable. I love her very much.

INTRODUCTION
"WE FACE AN UNCERTAIN FUTURE, BRACED WITH CONFIDENCE IN OUR PAST"

This book, Images of America: *Kankakee, 1911 to 1953*, is meant to be a companion to Images of America: *Kankakee, 1853 to 1910*, which was published in 2004. Together these books give a wonderful view of Kankakee's past. Most certainly an appreciation of the past has always been important to members of the Kankakee community. The Kankakee County Museum is the home of the Kankakee County Historical Society, which has been in the business of preserving knowledge of the area's past since 1906. The Kankakee County Historical Society is one of the oldest historical societies in Illinois. It was formally organized on December 14, 1906, "in response to a public call that Kankakee's story be preserved and presented to future generations." The Kankakee County Museum will celebrate the centennial of the Kankakee County Historical Society in 2006, continuing the work begun a century ago and in fulfillment of the Museum's simple mission statement, "To collect, exhibit and interpret the material culture of Kankakee County."

The chapters in this volume are arranged chronologically, rather than topically, picking up the Kankakee story in 1911 at the beginning of what some historians are already terming the "American Century." At the commencement of the second decade of the 20th century, Kankakee and the nation was still enjoying the remainder of an age of innocence that would be shortly shattered by the tremendous impact of the Great War, the 1914–1918 conflict and its aftermath, whose repercussions still ripple through the modern world. The images in the first chapter, 1911 to 1916, convey a sense of "small-town" America, showing Kankakee on the eve of two world wars and a major national depression. The images in the second chapter, 1917 to 1921, give a stark impression of Kankakee's Great War experience. The photographs of Kankakee during the Great Influenza Pandemic are particularly striking. Kankakee sent its National Guard formation, Company L, 3rd Regiment Illinois National Guard (later an element of the 3rd Battalion, 129th Infantry, 33rd Infantry Division) off to the war in France, along with 149 draftees, who became members of the new National Army. Lt. Anker Jensen, a Kankakee attorney, flew observation aircraft with the new American air corps, while Momence native Lt. Patrick O'Brien flew fighter planes with the Royal Flying Corps. The world they and their fellow veterans came back to after participating in President Wilson's Great Crusade was decidedly different from the one that they

had left. The images in the third chapter, 1922 to 1928, illustrate a postwar view of Kankakee. The Roaring Twenties may have captured the imagination of journalists and academicians, but in small-town America the atmosphere was mostly fairly conservative. To be sure, Kankakee had its share of flappers, but generally the community tried to embrace what President Harding called: "not nostrums, but normalcy." The images in the fourth chapter, 1929 to 1934, as well as those in the fifth chapter, 1935 to 1939, present a vision of Kankakee enduring the era of the Great Depression, which represented not only a very serious down-turn to the nation's economy, but in addition caused many individuals to question the validity of America's social and political systems. The photographs in these two chapters show the residents of Kankakee getting through perhaps the greatest crisis ever experienced by the Kankakee community. The images of several "Kankakee Prosperity Monthly Sales Days" graphically underscore the depth of the area's financial distress. The images in the sixth chapter, 1940 to 1945, give an impressionist view of Kankakee's participation in the Second World War, while the seventh and final chapter, 1945 to 1953, takes a look at the immediate postwar world in Kankakee. It was thought correct to end this volume in 1953 with images of Kankakee's centennial celebration in 1953. Commencing in 1853, with Images of America: *Kankakee 1853 to 1910* and ending a century of Kankakee photographic history with Images of America: *Kankakee 1911 to 1953*, it is hoped that the reader will come to appreciate the rich history and heritage of Kankakee and its citizens, who elected to establish their community along the banks of their "beautiful river." The legacy of everyone who created and sustained Kankakee for a century can be seen and heard daily around the Kankakee River by those who are willing to let their imagination wander just a bit. The creation of these books has been a fascinating project. The best reward will be that they bring enjoyment to those who read them.

One

1911 TO 1916

THE LAST DECADE OF INNOCENCE: "WE SEEM TO BE FINDING OURSELVES"

This 1915 image displays Court Street, the heart of the city of Kankakee, looking west in the first quarter of the 20th century. Representing the future, running down the center of the photograph, can be seen streetcar rails set into the cobblestone street, while overhead are the wires necessary to run the trolleys. At left sits an early automobile that still mounts kerosene lamps. The past is also well represented here in the right of the image by the hansom cabs waiting on the corner of Schuyler Avenue. In 1915, Kankakee was still a mixture of past and future. (KCMPC, P3120.)

The extended Lowe family is seen here gathered on their front step to celebrate Independence Day in the summer of 1912. In the back row are: Mildred and Ruby Butler and Mildred's husband David. Sitting in the center are: Stella Lowe, Melisa Butler, and Walter Lowe holding his son. The two gentlemen in dark suits to the right are Lawrence Lowe and Marvin Butler. Standing at left is local dentist, Dr. Donald Denton, and sitting in front are neighbors Mr. and Mrs. Callahan. The Lowe, Butler, and Callahan families were examples of the solid farming folk that populated Kankakee County. At the beginning of the 20th century, before the horrors of two world wars were known, Americans enjoyed the July 4 holiday with particular pride. (KCMPC, P3720.)

The Haswell Clarke carriage house, located on Kankakee's Harrison Avenue, appears in this 1912 photograph. In the late 19th century, Haswell Clarke was a prominent Kankakee banker and one of the city's most influential citizens. He was instrumental in convincing the state legislature to locate the Illinois Eastern Hospital for the Insane in Kankakee and became one of the city's most popular mayors, dying at his desk in the city office on the morning of January 16, 1901. The carriage house was converted into a private residence in 1919 by prominent area jeweler William Volkmann. (KCMPC, P5759.)

Before the modern communication era, the post office was a vital part in the daily life of any community. In 1853, Kankakee's first post office was located in a small frame house at East Avenue and Station Street. It was relocated several times to buildings housing private businesses, finally arriving at the Arcade Building in 1885. This 1913 photograph shows the first post office constructed as such, built in 1902 and located at the northwest corner of East Court Street and North Harrison Avenue. The white horse-drawn vehicles at lower right are marked "U.S. Postal Service, Kankakee, Ill. Rural Delivery." (KCMPC, P0322.)

By the first quarter of the 20th century, the business center of Kankakee was well established. This 1916 photograph shows the Knecht Building, which was built in 1869 and located at Court Street and East Avenue. It was owned by prominent Kankakee businessman John George Knecht, who operated a men's clothing store. Also located in the building in 1916 were Betourne's Pharmacy and Carlin Brother's Real Estate and Loan Office. The three gentlemen standing in J. G. Knecht's doorway are William "Birdy" Plants, Frank Holmes, and A. E. "Duff" Kerger. (KCMPC, P0205.)

11

It is rare that building exterior shots can be paired with interior views. The top photograph, taken in 1916 shows the interior of the J. G. Knecht Clothing Store. The exterior, also photographed in 1916, appears on the preceding page. Men's suits are prominently displayed in the center aisle, while Knecht employees A. E. "Duff" Kerger (left) and William "Birdy" Plants stand near the ready-made shirt counter. The bottom interior photograph shows the tobacco store lodged with the offices of the Chicago Interurban Traction Company and the United States Express Company, all located in the Arcade Building at the corner of Merchant Street and Schuyler Avenue. (KCMPC, P0483 and P0877.)

Many of Kankakee's male citizens were farmers. In this era, rural Americans were characterized by their inventiveness in adapting to the new century. Farmers found that Henry Ford's Model T could be put all sorts of uses. These two images show Arthur Lee of Kankakee and his 1912 invention, Lee's Power Transmission, which was intended to transmit power from a gasoline engine. The automobile could thus be used to run farm machinery. (KCMPC, P9742 and P9741.)

Increasingly at the beginning of the 20th century, Kankakee women joined the community workforce. This 1912 image shows the employees at Kankakee's Southside Overall Factory. The two men standing in the middle are apparently the foreman and his assistant. Three boys stand at left in the picture. The majority of the workers, however, are young women. (KCMPC, P5565.)

Young women seeking employment, rather than demurely waiting at home for a suitable marriage opportunity, became more common in the early 20th century. The attractive Margaret Goll was photographed in 1915. At the time she was working as a clerk in Kankakee's Chicago Store, but Margaret would never marry. She died a year later in 1916. (KCMPC, P8181.)

More traditionally, Grace Snyder married Harry Topping on October 24, 1912. She is shown here wearing her wedding dress. (Note the intricate lacing between the waist and the bodice.) The Snyder family was a solid and well-respected group of Kankakee County farmers, who had been working their land since the establishment of the county in 1853. (KCMPC, P9363.)

This image, made in November 1912, shows an amusing slice of life in Kankakee County. Clarence Eisenhower is seen about to pull Romeo Maillet down Kankakee's Court Street to pay off an election bet. The dapper Maillet had correctly predicted that the Democratic candidate Woodrow Wilson would win the 1912 presidential election. Eisenhower had supported the Republican Theodore Roosevelt, running on the "Bull Moose," or Progressive ticket. (KCMPC, P6251.)

These Kankakee ladies are seen here indulging their sense of the whimsical at a Halloween Party held in October 1912. Wearing sheets, these ghosts are ready to pull their masks down to impersonate the "other worldly." Four of the goblins are shown holding carved jack-o-lanterns. (KCMPC, P1811.)

15

In the first quarter of the 20th century the increasing prevalence of the automobile nearly revolutionized American society. This touring car was photographed crossing the Kankakee River at Kankakee's East Court Street Bridge on Sunday, May 9, 1915. The Lancaster family is out with their "Jeffery," participating in a new American custom, the Sunday drive. (KCMPC, P8251A.)

With the arrival of the automobile, car dealerships came to Kankakee. This 1916 image shows the interior of the Fortin Garage and Buick Showroom, located on Kankakee's East Station Street. The touring car in the right of the photograph is a Dodge. Fortin's car salesmen are standing behind it. The owner, George Alma Fortin, came from a well-established Kankakee family of farmers, businessmen, and bankers. (KCMPC, P8150.)

The mechanics of the Fortin Garage are shown here in this group photograph taken in 1916. Early-20th-century automobiles were much simpler than their modern counterparts; still it often took young muscle to maintain them. Note the starting crank and suspension system of the vehicle sitting at the left of the picture. (KCMPC, P2896.)

Before World War I car racing became increasingly popular. This photograph was made at the Kankakee County Fair in the summer of 1911, showing race car numbers 6, 24, 18, and 9 at the starting line. The drivers are wearing goggles and face cloths to combat the dust of the dirt track. (KCMPC, P1641.)

In the early 20th century, the automobile soon found utilitarian uses. In this 1916 image six Kankakee City firemen are shown with their new auto-engine, parked in front of the Kankakee City offices. The vehicle mounts an innovative pressurized water delivery system. (KCMPC, P0006.)

These gentlemen seem to be using the automobile for an early-20th-century ritual, visiting a saloon. They were photographed in 1914, taking their open touring sedan to A. G. Betourne's establishment, the Monogram, located at 187 Court Street in the city of Kankakee. Betourne's saloon was much favored by Kankakee County area railroad workers. (KCMPC, P8251B.)

In the top left image, made in 1912, Mrs. Alden Prew is seen at the wheel of her family's new automobile, parked in front of her house located on Kankakee's South Dearborn Avenue. In the rear seat Mrs. Prew's sister, Mrs. Melvina Bernier is seen wearing a dark suit and playfully, or perhaps symbolically, wearing a man's hat. The other woman is unidentified. At top right, an unidentified Kankakee County family is seen going out for a summer's outing with their Jeffery, on June 21, 1914. At bottom an unidentified group of women are seen enjoying their picnic along the Kankakee River, also in the summer of 1914. (KCMPC, (P8254, P3446A and P5507.)

Amateur theatrics were an important source of entertainment in early-20th-century Kankakee. In the top image, assembled for a group portrait, is the cast of the 1915 class play held at St. Paul's Lutheran School. At bottom is the cast of a play done by the St. Viator College thespians. (KCMPC, P4733 and P8865.)

Kankakee area schools provided musical entertainment, as well as amateur theatrics. At top, the Kankakee High School Orchestra is shown in 1912. They are, from left to right, (first row) Harry Thompson, Elmer Brown, Harold Swope, and Arthur Bishop; (second row) Carl Wolf, Kenney McDowell, Frederick Jansen, William Fowler, and Ralph Sutton. Parades and brass bands were also popular forms of entertainment. At bottom, an unidentified brass band leads the Farmer's Union of America down Kankakee's Court Street in 1916. They are just crossing Schuyler Avenue. (KCMPC, P0405 and P2791.)

One of the most impressive social events taking place in Kankakee before World War I was the wedding of Kankakee's Dorothy Linn to Cyrus McCormick III. The wedding was celebrated at Kankakee's Presbyterian Church in 1914. Sarah Seymour Blair (left) is seen entering the church for the ceremony with Herisca Clark (right). (KCMPC, P2025.)

By the last decade before World War I, the motion picture had captured America's imagination. Gladys Smith was discovered by David Wark Griffith's Biograph Studio. As Mary Pickford, she was arguably the single most popular star in the early silent picture era. The signed photograph of "America's Sweetheart," appearing on the left, was acquired at her Chicago appearance in 1914 by a Kankakee resident. At right is a 1914 portrait of Miss Lucille Jeanette Smith, a less well-known beauty. She lived on Kankakee's Chicago Avenue. (KCMPC, P1393 and P9042B.)

These two images, dated to 1912, show three unidentified Kankakee ladies. At upper left, a lovely young woman stares out toward the camera in what may be a graduation portrait done for an area Catholic school. At upper right are two apparent sisters dressed for a winter stroll. (KCMPC, P9800 and P9801.)

A wonderful sense of prewar whimsy was captured in this novelty image made at the Kankakee County Fair in the summer of 1914. Sitting as the "man in the moon," Kankakee farmer James Tennis seems to be viewing the last summer of general worldwide peace with a certain detachment. (KCMPC, P8375.)

In 1916, two summers after the outbreak of general European war, the United States War Department was forced to federalize elements of the National Guard and order them to duty on the American-Mexican border. They went to defend American territory from incursions by Mexican irregulars, like those led by Mexican General Francisco "Pancho" Villa. This photograph shows Kankakee's National Guard unit, Company L/3rd Regiment Illinois National Guard on September 13, 1916, leaving the Illinois Central's passenger depot for Texas. A large crowd has come to "see the boys off" on their adventure. (KCMPC, P5645B.)

In the manner of all armies and in all campaigns, however, most of Kankakee National Guardsmen's 1916 border experience was rather less than romantic. This photograph shows Company/3rd Regiment Illinois National Guard waiting in a chow line, at Camp Logan, Leon Springs, Texas. Service on the Texas border in 1916 would later prove valuable to the men who were sent to France for service in the Great War. (KCMPC, P1842.)

24

Two

1917 TO 1921

KANKAKEE AND THE GREAT WAR: "MAKING THE KAISER DANCE"

Lt. William Deneau is pictured in this magnificent portrait, made in early 1917. Many of the Deneau family worked for the "Big Four" Railroad in Kankakee. The crossed rifles on his collar insignia indicates service in the infantry, while the "ILL" indicates that his commission is in the Illinois National Guard. Some National Guard officers stubbornly refused to remove their state collar insignia for the newly mandated "U.S." Nonetheless, all of them went "over there" in a united American war effort. The first man drafted in Kankakee County was Stanley Barckih of Bradley. In August 1918, all previous distinctions were removed and all officers were given commissions in the combined National Army. (KCMPC, P1207.)

On September 17, 1917, Kankakee's National Guard unit, Company L/3rd Regiment Illinois National Guard marched down Court Street to the New York Central Railroad Depot, where they boarded a train for Camp Logan, Texas. In 1916, these men had seen service on the Texas/Mexico border. Thier blanket rolls give the air of veteran campaigners. The night before their fellow citizens had given them a farewell dance at Kankakee's Electric Park, and here in this image a brass band provided by the Illinois Central Railroad is seen leading them off to war. Company L would fight in France as part of the 129th Infantry Regiment/33rd Infantry Division (Illinois National Guard). (KCMPC, P5645A.)

These four Kankakee citizen soldiers, wearing overcoats and their campaign hats, were photographed at the end of their training in November 1917. They are posing against a photographer's painted backdrop made to resemble the rear end of a railroad car taking them on their journey overseas aboard the "Sunset Limited." Shortly they would take a real train for an embarkation point near Newark, New Jersey. (KCMPC, P8267.)

The top photograph was taken at Camp Logan, Texas, in October 1917. It shows the officers of the 3rd Battalion/129th Infantry discussing a tactical problem on a sand table. The 129th's colonel is the officer sitting sixth from right. Sitting to his left (fifth from right) is the 3rd Battalion's commanding officer. Company L was a part of the 3rd Battalion/129th Infantry. The bottom photograph was taken behind a main trench line in France occupied by Company L in November 1918. The lieutenant in the middle is wearing the shoulder patch of the 33rd Division, which indicates that the photograph was taken later in the war, as shoulder patches were not authorized until fairly late in the conflict. (KCMPC, P8857 and P5446.)

These two fine quality 1917 images show two of Kankakee's participants in the Great Crusade. At upper left is Pvt. Jesse Forque of the 33rd Division, wearing his campaign hat. He has added a paper collar to his fine quality enlisted blouse to formalize his portrait. At upper right is Pvt. Leon Fortier, serving with the signal battalion of the 33rd Division, who has also added a paper collar, in this case, to the standard enlisted man's blouse. On the back of the picture-postcard he wrote: "This is my trump picture!" (KCMPC, P8268 and P8264.)

These two American infantrymen are holding their 1903 Springfield Rifles at port arms. The "03" was perhaps the most accurate weapon ever carried by the U.S. Army and it was the standard American shoulder arm at the beginning of World War I. This photograph was taken at Fort Snelling, Minnesota, on September 16, 1917. Some Kankakeeans were already members of the regular army, such as Frederick Barnes standing at left, who was "soldiering" with the 41st U.S. Infantry. (KCMPC, P5711.)

The creation of the National Army and the initial 80 Division program meant the army immediately needed specialist and professional officers in large numbers. As a result, qualified physicians received direct commissions in the Army Medical Corps. This is an excellent portrait of Dr. Gilbert Ayling, a Kankakee County doctor, who is shown as captain and assistant surgeon/medical corps. After his service, Dr. Ayling established a small medical practice in St. Anne, but relocated to Kankakee in 1928 to a bigger practice conducted in the Volkmann Building on Evergreen Avenue. (KCMPC, P1441.)

Powered flight was a recent innovation in the early 20th century. World War I fighter pilots were particularly lionized. Bishop, Mannock, Voss, and Richthofen became household names. This photograph is a 1918 image of Kankakee native Lt. Anker Jensen, who was a fighter pilot in France with the A.E.F. Following his service flying over the trenches in France, Jensen became a lawyer in Kankakee with his office on East Court Street. (KCMPC, P5676.)

Lt. Harold Gilbert is shown here in this excellent 1919 portrait. He served as a pilot in the Great War with an observation squadron attached to the aviation section of the 1st U.S. Army. By 1925, Gilbert was employed as the manager of United Mill Products, located on Kankakee's South Evergreen Avenue. (KCMPC, P1206.)

Kankakee native Patrick O'Brien flew with the United States Army Signal Corps in 1916 in northern Mexico. Seeking further aviation adventure, O'Brien went to Canada in early 1917 to enlist in the British Royal Flying Corps and arrived in France with the RFC in the spring of 1917. He was shot down, but managed to escape back to Allied lines during a 72-day odyssey. After his safe return, Lieutenant O'Brien was formally received by the King of England. This period image shows O'Brien standing with what looks like a British SE 5. In the postwar period, he went to California to perform aerial stunts for motion pictures. Kankakee's "adventurer" was found dead, a supposed suicide, under mysterious circumstances, in 1920. (KCMPC, P1394.)

During World War I, the American military effort in France was actively supported by those remaining in Kankakee. Some excess was generated by patriotic enthusiasm, for example, the First German Baptist Church of Kankakee was forced to change its name to Immanuel Baptist, German language instruction was halted at the Kankakee High School, and on April 5, 1917, every Kankakee citizen over 18 was expected to sign a loyalty oath. Some expressions of civilian patriotism were more productive, such as selling and purchasing government war bonds, an effort being supported in 1918 by this float made by the employees of the Kankakee State Hospital. (KCMPC, P5972.)

This 1918 photograph shows two Kankakee natives, both officers in World War I. At left is Lt. William Beckhelm of the field artillery, who may have remained stateside during the conflict since he is not wearing a Sam Browne belt. At right is Lt. Roy Dusenbury of the infantry, wearing a Sam Browne and missing his left leg below the knee, most certainly a combat veteran of the A.E.F. After the war both of these men worked for the U.S. Postal Service, Beckhelm as a mail carrier and Dusenbery as the postmaster of Kankakee. (KCMPC, P0529.)

The fighting in France came to an end with astonishing suddenness on November 11, 1918. The participation of America's A.E.F. proved vital in preserving the Allied cause, particularly in halting the German offensives in the first half of 1918. The larger picture shows a float contributed by the employees of the Kankakee State Hospital to Kankakee's victory parade. The oval insert shows the last, rather tired looking commanding officer of Kankakee's Company L/129th Infantry. His photograph was taken in France on November 12, 1918, the day after the fighting stopped in the "war to end wars." (KCMPC, P8858 and P9284.)

The employees of Kankakee's Kaustine Company and some of their families are seen here ready to march in Kankakee's 1918 victory parade. The gentleman standing directly under the "a" in the word company appearing on their banner is Clarence Kirchner, who, within a few years, would be the sheet metal foreman for the Kankakee firm of Henry Reuter and Sons located on Kankakee's West Avenue. (KCMPC, P9195.)

33

A horrific consequence of the Great War was the terrible influenza pandemic that affected the world between April and December 1918. It made a serious impact on the United States by September and would kill over 500,000 Americans by the end of the year. Estimates for plague-related deaths worldwide range from 20 to 100 million. Many of Kankakee's influenza victims would have been brought to the Kankakee Emergency Hospital located on the corner of North Fifth Avenue and West Merchant Street, pictured here in October 1918. The emergency hospital was later renamed St. Mary's Hospital. Slightly over 300 Kankakee citizens died directly from effects of the 1918 Spanish Influenza. (KCMPC, P0204.)

Other Kankakee influenza sufferers were treated at the privately operated Barrett Hospital, shown here in this photograph taken in late October 1918. At the time of the great influenza pandemic, the Barrett Hospital was a new medical facility in Kankakee. The Barrett family had purchased the Briggs-Lillie House only in 1914 for conversion to a private hospital complete with then, modern operating rooms. Noted Kankakee builder James Lillie had constructed the house in 1869 for J. Smith Briggs, a Colorado coal mine magnet. Lillie purchased the house in 1884. (KCMPC, P0064B.)

This is a 1917 image of Annie Laurie Geron, a Kankakee native who joined the Signals Branch of the U.S. Navy at the beginning of World War I. The navy, however, by the middle of 1918, was forced to reassign her to nursing duties to treat the influenza pandemic. (KCMPC, P9049.)

These three nurses were employed at the Barrett Hospital, where working with influenza patients would have exposed them to the disease. They are, from left to right, Elizabeth, Josephine, and Agnes Barrett. Elizabeth and Agnes were sisters. Josephine was their sister-in-law, as she had married William Barrett, the hospital's chief administrator. The photograph was taken in November 1918. (KCMPC, P9038B.)

In this 1918 image, a private horse-drawn ambulance from Kankakee's Sherwood and Dick Ambulance Service is shown being used to deliver corpses to their Kankakee establishment, where they also offered funeral services. Joseph Dick had operated a joint livery stable and undertaking business since 1894. Having passed a newly mandated state examination in 1903, he was considered one of the most reliable of Kankakee's licensed undertaker and embalmers. (KCMPC, P9547.)

The human cost of the Great War and the resulting influenza pandemic is graphically illustrated in this photograph. It shows a Kankakee area funeral procession in early 1919 for several victims of the Spanish Influenza. On the right, or far side of the white ambulance, from left to right, are Capt. Frank Burns, Pvt. William Gousset, and Lt. Harry Streeter. On the left, or near side of the ambulance are, from left to right, Pvts. James Clifford, Elof Peterson, and Kelson, with Lts. Anson Nickerson, William Beckhelm, and Roy Dusenbury. Lieutenants Beckhelm and Dusenbury appear previously on page 32. (KCMPC, P3804.)

The two images on this page place a face to tragedy. The top photograph is a portrait of Edna Allain Dyon. Her father Ambrose Allain and his brother Antoine were the first settlers in the village of St. Anne, Kankakee County. The bottom photograph shows her in her coffin, one of the earliest victims of the influenza pandemic. She died on February 3, 1918, leaving behind her husband and five children, to rest in the St. Anne cemetery. (Courtesy of the William Dyon Collection.)

The next few images illustrate slices of Kankakee life in this period. In this image, the 1918 Kankakee High School basketball team is shown gathered for their group portrait. Basketball had only been introduced at the High School in 1914, but through four seasons the "Maroon and Blue" had not enjoyed much success. The student sitting at center holding the ball is team captain Alfred Radeke. The gentlemen wearing suits are the team coaches, Russell Giffon and Andrew Ogden. (KCMPC, P0755.)

The members of a first grade class are seen in this 1920 image, commencing their academic career in the town of Bradley, which 25 years before had been a part of the city of Kankakee. One of the little girls, appearing at right center, is holding a school slate inscribed: "Our First Year, 1920." (KCMPC, P5559.)

Claude Bruner was a well-known Kankakee area bandleader. He is shown here in this 1918 photograph with his wife Mildred "Millie" Bruner. Millie worked as a nurse at the Kankakee State Hospital, formally the Illinois Eastern Hospital for the Insane. Bruner was killed in 1920 in an automobile accident north of Grant Park in Kankakee County. He was on his way to a musical engagement. (KCMPC, P8621A.)

The lovely Florence Gast, shown in this 1918 autographed picture, was a dancer. She performed in Kankakee accompanied by her brother Norman playing the violin, along with another native Kankakee musician, Samuel Shapiro. Shapiro was working his way through law school playing the violin. Samuel Shapiro would become the lieutenant governor of Illinois in 1964 and Illinois' governor in 1968. Florence later married "Benny" Pollack, a famous dance-band leader in Kankakee during the Great Depression. (KCMPC, P5336.)

The meat section of Kankakee's Childs and Pahnke Market, located on Court Street, is depicted here as it was in early 1921. The four gentlemen butchers are, from left to right, Frederick Betourne, Gus Boucher, Walter Childs (owner), Walter Oertel, and Neal Bunker. Bacon is selling for 32¢ a pound and roast seems to be going for 18¢ to 35¢ a pound. (KCMPC, P2457.)

In 1921, Kankakee fireman Art Steyers was killed in an explosion in the 100 block of Kankakee's North Greenwood Avenue. Shown here is his funeral procession. His fire-fighting colleagues are gathered around him one last time. Kankakee's fire chief, Emile Goudreau, is sitting in the passenger seat. The stone building at left center is Kankakee's Baptist church, while the brick structure at right center houses the Kankakee Police Department and jail. (KCMPC, P4753.)

At top left is the strikingly beautiful Ruth Marie Marcotte in her commencement portrait. Marcotte became a well-known vaudeville singer, as well as a respected classical soprano. In reviewing Marcotte's performance in the musical *Topsy and Eva*, a Chicago critic said that she, "combines a beautiful voice of most uncommon quality, which she uses skillfully, with a most winsome and charming personality." The 22-year-old stage star died suddenly from complications from an appendicitis operation. In the top right image, William Volkmann and his bride, Cecilia Bimm Volkmann, are seen enjoying rather simpler pleasures. On October 20, 1918, they have paused on a bridge spanning the Kankakee River. The young couple was on their Sunday afternoon outing with their brand new motorcar. William Volkmann worked for his well-established family jewelry business. (KCMPC, P5587 and P8674.)

The automobile was quickly changing the character of American society. Henry Ford had made it practical for every middle class family to own a car and the postwar profusion of automobiles made it necessary to build roads. This 1921 image depicts Frederick Bally standing on his road grader. He is working road construction in rural Kankakee. (KCMPC, P3415.)

41

Kankakee native Lennington Small served as governor of Illinois between 1921 and 1929. First elected as the Republican Party candidate for governor in 1920, he was successfully re-elected in 1924. This formal portrait was made of Gov. Lennington Small in 1920 during his first gubernatorial campaign. He was born in Kankakee on June 16, 1862, the fourth child of Dr. Abram Lennington Small, prominent area landowner and physician. During Governor Small's two administrations, over 7,000 miles of all-weather hard surface highway were constructed in Illinois, earning him the title of "the Good Roads Governor." (KCMPC, P3336.)

The woman standing in the middle of this 1921 photograph wearing the fur coat is Ida Moore Small, whose husband Lennington Small had just been elected governor of Illinois the preceding November. The coatless woman at right is their daughter, Ida May Small. The automobile is an early electric car, much favored by fashionable ladies of this era, as it did not have to be started with a crank. Governor Small's first administration was, unfortunately, marred with charges of financial scandal that originated with his political enemies and supposedly dated from his time as Illinois secretary of state. He was acquitted in a criminal case. His victory shortly turned to tragedy, however, for on the evening of June 25, 1922, after celebrating his victory at a party held in his Kankakee home, Ida Small suffered a severe stroke, from which she died the next day. (KCMPC, P3850.)

This 1920 image shows Lennington Small's home, located on Kankakee's West Station Street, decorated for Election Day in 1920. Small's picture appears at center as the Republican Party candidate for the governorship of Illinois. He is flanked with portraits of the Republican Party presidential candidates for the national election. At the right of the photograph hangs a picture of Warren Gamaliel Harding. At the left of the photograph hangs a picture of Calvin Coolidge, Harding's vice president, who succeeded to the presidency after the death of President Harding. Coolidge was elected to another full term as president of the United States in 1924. Small was elected governor of Illinois in 1920 and again in 1924. (KCMPC, 2578.)

Kankakee banker Edward Curtis is seen here in this 1918 image. Curtis was a prominent figure in Illinois state politics, having first been elected to the Illinois state legislature in 1894 and having served in the Illinois state senate since 1904. He was largely responsible for securing the Republican Party nomination to Illinois secretary of state for Lennington Small, thus propelling a fellow Kankakee citizen up the Illinois state political ladder. (KCMPC, P1874.)

These two 1918 photographs show the Shreffler family enjoying their new Ford touring car. The following are shown in the upper image: in the front seat is Mott Shreffler, who worked as a farmer and dairyman in Bourbonnais Township, and his wife Amy Hotchkiss Shreffler. In the left rear seat is Mott's brother Ulysses, who was a farmer in Kankakee's Limestone Township. The two girls, also seen in the backseat, are Mott's daughters Opel and Marion. In the lower image, the charming Opel Shreffler is seen playfully taking the wheel of the new family Ford. It came in any color you wanted, so long as you wanted black. (KCMPC, P2368 and P2367.)

Three

1922 TO 1928

STARTING BACK TO NORMALCY: "THERE SEEMS TO BE BUT LITTLE BALLYHOO HERE"

Kankakee High School first organized a band in 1921. In 1923, the band became a marching band and it is shown here posed in front of Kankakee High School after the 1923–1924 season. The 1924 Kankakee football team only had a 4–5 season. "Not so successful when one looks for the games won," remarked Coach Bean, "but very successful when one considers the pep which was a prominent characteristic of our school athletics this year." One can only hope the new Kankakee High School marching band contributed to that spirit. "Kankakee! KEE KO KAN Who Can? We Can! Kankokeekan!" (KCMPC, P0753.)

Kankakee's City Hall is seen (at top) in this 1924 image. The building stands on East Oak Street, which is just off North Harrison Avenue. In addition to housing the city offices, the structure was also home to one of Kankakee's fire stations. Two of the city's fire engines can be seen at left. One of Henry Ford's creations can be seen parked opposite the entrance to city hall. In the third decade of the 20th century, Kankakee looked forward, as did the rest of the nation, to further industrial advances. A spirit well illustrated by this group of cheerful Kankakee City employees, who were photographed together (below) in 1925. (KCMPC, P6614 and P9330.)

46

New construction in downtown Kankakee symbolized the positive spirit of the 1920s. This 1925 photograph captures the moment the first spade of earth was dug to begin construction of the new Hotel Kankakee, which would be located on the corner of Schuyler Avenue and Merchant Street. By 1927, the seven-story Hotel Kankakee accommodated guests in 150 rooms, serving meals in their Coffee Shop and "Indian Dining Room." (KCMPC, 9732B.)

A great number of homes were constructed in Kankakee during the mid-1920s, many of which were probably financed through the Kankakee Building and Loan Association. Founded in 1885, the Kankakee Building and Loan Association maintained assets of $4.25 million by 1927. This image, made in October 1923, shows the interior of their office located on East Merchant Street. The five female employees are, from left to right, Gertrude Greenwood, Blanche Karr, Selma Kegley, Eleanore Andrews, and Mary Doyle. (KCMPC, P9670.)

Kankakee had held a farmer's fair since 1856. It remained a minor local event until 1890, when the fair board came under the control of Lennington Small. By 1900, the annual Kankakee Inter State Fair attracted thousands of people from all over Illinois and surrounding states. The fair maintained numerous agricultural exhibits, but it was other attractions like the well-known horse racing competition that drew the crowds. The Great Depression brought the fair to its end. Patrons of the Kankakee Inter State Fair are seen in the top photograph arriving at the fair's main gate in 1923. The North Kankakee Street Railway Company (formed in 1892) laid its earliest rack straight to the fair grounds to deliver visitors direct to the front gate. People came to see the new and different. In the bottom photograph, also taken in 1923, are a lion tamer and his four big cats just after their arrival at the fair. (KCMPC, P1623 and P1470.)

Visitors came to the Kankakee Inter State Fair to see novelties and experience a little excitement. In the top image, taken in 1927, fair patrons are seen inspecting planes lined up on the fair grounds. The aircraft at right is a Ford Tri-Motor, which was first made available in June 1926. At county fairs, former military pilots performed acrobatics. "Barn-storming" became a regular feature at the Kankakee Inter State Fair. In the bottom 1927 image, young Eugene and Billy Goll are seen standing with a Waco biplane belonging to the Koerner Family of Kankakee. A few minutes after this picture was taken, the biplane crashed while stunting for the crowd. The pilot was killed. (KCMPC, P2588 and P8192.)

Kankakee native Lennington Small, Republican governor of Illinois between 1921 and 1929, was a life-long supporter of the Kankakee Inter State Fair. In the top photograph, he is shown smiling (fourth from left) with a living example of the Republican Party's symbol. They both appeared at the Kankakee Inter State Fair in 1924. This stunt photograph opportunity was arranged to support Governor Small's successful 1924 campaign to recapture the Illinois gubernatorial seat. The bottom photograph was also taken during the 1924 election. Centered on the 100 Block of North Indiana Avenue in Kankakee, it shows the crowd gathered to cheer Governor Small's procession to the 1924 Kankakee Inter State Fair. (KCMPC, P4642 and P9294.)

Governor Small had a real interest in agrarian matters. He maintained a large show-place farm in Kankakee, where he kept a prize-winning herd of purebred Holstein cattle, as well as numerous other farm animals. The top image, taken in 1928, shows the governor (wearing a suit) aboard his new tractor. Beside him stands his eldest son, "Bud" Lennington Small, who actually ran the farm for his father. The bottom photograph shows the Small family around 1930. They are, from left to right, newspaper editor Leslie Small, the governor's second son; Grace Burrell Small, Leslie's wife; Lennington Howard Small, the governor's son; Gov. Lennington Small; Ida May Small English, the governor's daughter; Col. Arthur English, Ida's husband; Jacqueline English, Ida and Arthur's daughter; and, at far right, "Bud" Lennington Small. (KCMPC, P1798 and P3776.)

Following the end of the Great War, veterans very quickly organized themselves into the American Legion, which eventually had a post in virtually every community. In the decades immediately after World War I, the American Legion provided a vehicle for social gatherings in many small towns. These two images are cast pictures for the annual American Legion musical held in Kankakee throughout the 1920s. The photograph appearing at top shows the cast of the Kankakee American Legion, Post No. 85 musical for the 1923 season, *Buck on Leave*. At bottom is the cast picture for the following year, the *Musical Revue of 1924*, which apparently had a South Seas theme. Notice that several of the actors are wearing "black face" makeup. (KCMPC, P0773 and P0768.)

Shown here is the Kankakee High School football squad for the 1922 season. At right, standing in the second row and wearing a suit, is the team's coach Euclid Lambert. The school yearbook, the *Kankakeean*, noted that, "With a wealth of good material and a real coach, things looked fine for a successful season." Coach Lambert's team ended the 1922 campaign with a 5-3-1 record. Sitting third from right in the team photograph is an African American player. It was rare for a school to field a racially mixed team in this era. (KCMPC, P6630.)

Some of the "boys of summer" are seen here gathered for their team portrait in 1924. This Kankakee minor league baseball team was sponsored by Kroehler Manufacturing. Kroehler Company produced furniture. They established their first factory at Naperville, Illinois, in 1892. In 1910, Kroehler located a large plant in Kankakee County, which by 1924 was the largest factory in the Kroehler system, producing 16 train carloads of furniture every day. (KCMPC, P0828.)

53

The people of Kankakee worked at a variety of trades. This 1922 image shows the interior of Erzinger's Bakery, a department of Erzinger Pure Food Stores, located on East Court Street. It was the largest retail grocery business in Kankakee. The Erzinger family had been selling food items in Kankakee since 1891. Standing behind their work, from left to right, are Romeo Maillet, Jack Fitzgerald, Earl Beckhelm, and Louis Macher. (KCMPC, P8232.)

In 1924, this work crew was photographed laying a water main across the Kankakee River. They are placing pipe on the south side. The north bank of the Kankakee River can be seen behind them. (KCMPC, P0770.)

The offices, vehicles, and employees of the Rivard and Benoit Coal Company are seen here in this 1926 photograph. Located on Kankakee's North Dearborn Avenue, the firm was jointly owned by Alphonse Benoit and Jerry Rivard. "We have the coal you need," ran their advertisement, which offered Eastern Kentucky, Harrisburg, and Semi-Anthracite Coal and added: "Quick service is our motto!" (KCMPC, P2770.)

In February 1923, the Kankakee chapter of the Young Men's Christian Association held the grand opening of their new facility, which had been relocated to North Indiana Avenue. These 72 ladies represented Kankakee society at the event. The YMCA originated in England in 1844, arrived in the United States seven years later, and was widespread in America by the late 1880s. The Kankakee YMCA was firmly established by 1890, offering reading and meeting rooms, as well as maintaining athletic fields for "promotion of the spiritual, intellectual, physical and social welfare of men and boys." (KCMPC, P6067.)

The 1920s are sometimes referred to as the Jazz Age. The common impression of this period portrays American youth acting rather wild in the postwar world. The dapper Eugene Leetch appears in this 1928 image, holding his cornet, which he played in a Kankakee Jazz Band. The music he produced with his colleagues would have been seen as dangerous by more conservative elements of Kankakee society. (KCMPC, P1236.)

The flapper, sporting bobbed hair and displaying more of her anatomy in rather flimsy dresses than was customary, came to symbolize the 1920s. At left is Miss Alyce of Kankakee, seen sitting in the summer of 1928, strumming a banjo and provocatively showing her legs below the knee. In 1933, she married Albert "Big Jim" Hale, a director-producer in Hollywood, California. At right is a 1927 image of another Kankakee flapper, Beatrice Kelly, who is wearing the wrap-around coat common in the period, as well as displaying her bobbed hair and shapely legs. She was photographed standing with her boyfriend Earl Offerman's sedan. (KCMPC, P3651 and P3922.)

The 1920s were, however, a fairly conservative period for most people. If the young seemed rebellious, many more mature Kankakee citizens still represented the typical values of small-town America. The 49-year-old Paul Winkel, shown here in this 1926 photograph, is an example of such middle-class respectability. Winkel worked in Kankakee for years as a butcher for Erzinger Brothers Pure Food Store. He and his wife Bessie lived on Kankakee's Sixth Avenue. (KCMPC, P2335.)

The rebellious flapper often settled down too. This 1930 photograph shows the Offerman wedding party. (Beatrice Kelly Offerman is seen before her wedding on page 56.) Her attendant, Dorothy "Fedde" Spohrer, stands at her right. The usher seated next to the beautiful bride at her left is unidentified. Her new husband, Earl Offerman, stands behind his bride. Earl Offerman worked as a projectionist for Kankakee's Lyric Theater, located on Washington Street. (KCMPC, P3920.)

57

Kankakee enjoyed the last year of "Coolidge Prosperity," blissfully unaware that the nation's economic progress was about to be drastically halted. Part of Kankakee's business district is seen in this 1928 photograph, showing a view looking west from Dearborn Street along Merchant Street. Tracks for the electric streetcar line run down the center of the image, leading directly to the passenger depot of the Illinois Central Railroad. (KCMPC, P0767.)

Hope for continued growth in the city of Kankakee is evidenced by this gathering, photographed in front of the Kankakee County Court House in 1928. They are all area businessmen and members of the Kankakee Chamber of Commerce. Exactly what they meant by their sign, "30,000 by 1930," is undetermined. It does seem to indicate, however, a firm belief that their community would continue to improve and prosper. (KCMPC, P1943.)

Four

1929 to 1934

The Great Depression: "We Are Not Quite Down and Out"

This photograph was taken on a warm day in May 1934. Many of the gentlemen in the picture are coatless. Even at the height of the Great Depression, Kankakee's East Court Street seems rather busy. You could have had lunch at Ortmann's (seen at right) for only 25¢, if you could dodge the rather eccentric traffic pattern apparently in use on Court Street. A department store on the south side of Court Street has posted the sign, "Don't Forget Dad's Day, Sunday June 17th." There is even new construction for additional businesses taking place on the corner of U.S. Route 45 and Court Street. The nation was experiencing the worst economic upheaval in its history, but everyday life continued in Kankakee. (KCMPC, P9707.)

Photographed on a Sunday afternoon on the eve of the Great Depression, this 1929 image shows the main plant of Bear Brand Hosiery. It was the largest industry in Kankakee and the greatest single employer in the city. In 1893, Henry Pope founded the Paramount Knitting Company at Kankakee, which was reorganized as Bear Brand Hosiery in 1922. The old title can be seen on one of the buildings. In 1929, their central manufacturing plant was located on South West Avenue and Hickory Street, with branches on Kankakee's Dearborn Avenue and in nearby Bradley. Bear Brand operated a retail outlet on Kankakee's Washington Avenue, but their really important business came from shipping socks and nylons across the middle-west along the track of the Illinois Central Railroad. (KCMPC, P5213.)

On a workday in September 1929, five female employees of Bear Brand Hosiery (formally Paramount Knitting) were photographed outside the main Kankakee plant. They seem to be enjoying the noontime sunshine on their lunch break. They are, from left to right, Margaret Fleming, Anna Erickson, Laura Scheismer, Rosemode Wilson, and Florence Legotte. (KCMPC, P9180.)

The City of Kankakee established a board of education after the Civil War, committing Kankakee to providing free public education. In 1902, all city schools came under the board's direction and were regularized in the process. The students, teachers, and parents of Kankakee's Whittier Grammar School are seen here gathered for an assembly. This photograph was taken around Easter 1929. The building used by the Whittier School in this era, located in the 100 block of South Orchard Street, subsequently was used as a City of Kankakee storage facility. (KCMPC, P3165.)

This matronly portrait of Dr. Violet Palmer Brown, made in 1929, seems to epitomize Kankakee middle-class respectability in the late 1920s. In her youth, Dr. Brown was an unusual woman for her era. She graduated from Chicago's Northwestern University Medical School in 1898 and she practiced medicine in Chicago until relocating to Kankakee with her husband in 1902. She and her husband, Dr. John Archibald Brown, also a physician, would continue to practice medicine in Kankakee for over 50 years. (KCMPC, P1385.)

A good deal of criminal activity in the 1920s was caused by Prohibition. The first illegal still was found in Kankakee County in November 1920. Local law enforcement agencies, however, considered the enforcement of prohibition to be a federal matter. The City of Kankakee Police Department, seen here in a group portrait taken on the steps of city hall on June 12, 1929, shows off their new Harley Davidson motorcycle, straddled in the image by patrolman Edward LaFountain. Police chief Owen Sullivan stands in the middle, with his six plainclothes detectives behind him and his 12 patrolmen in front. At the upper right of the group stands Pearl McCorkle, police dispatcher. (KCMPC, P1814.)

Edward Klafta joined the Kankakee Police Department in 1930. His uncle Edmund and his father Edward were partners, working in Kankakee as upholsterers. This 1934 portrait photograph of Edward Klafta shows him as a newly appointed police lieutenant. He has a rather hard-boiled look. (KCMPC, P1126.)

This aerial photograph of Kankakee displays the community served by Lieutenant Klafta and his colleagues. The city of Kankakee's main commercial artery, Court Street, can be seen in the image's center, located on the north side of the Kankakee River and to the right of the railroad bridge. The open ground at top center is the Kankakee County Fairground. The photograph was taken on May 21, 1930, by the Chicago Aerial Survey Company. (KCMPC, P9188.)

A work crew is seen here in this 1928 photograph constructing a grain elevator on Kankakee's North Entrance Avenue. Agriculture remained an important business in Kankakee in this period, although here, as was the case throughout the country, farm prices continued to fall throughout the 1920s. As a consequence, farmers failed to benefit from Coolidge Prosperity. This fact proved an underlying cause of the Great Depression in 1929. (KCMPC, P1283.)

The 1920s were characterized by spectacle, major league sporting contests, fads like flag pole-sitting, the motion picture, and titillating newspaper stories appropriately laced with scandal. During the 1920s, Kankakee possessed a marching band of national champion quality that on many occasions gave the city quite a show. This 1929 image is an impressive portrait of their leader, Harry Thompson, resplendent in his drum major's regalia. Thompson worked in city hall as Kankakee's chief city clerk. (KCMPC, P1260.)

The American Legion marching band of Kankakee Post No. 85 is seen here gathered for their group portrait taken beside the Kankakee County Court House building in 1928. The photograph was made shortly after their return from France, where they won second place in an international competition held in Paris. In 1928, the previous year they had won first place in a national contest held in Louisville, Kentucky. Drum-major Thompson can be seen standing at center. (KCMPC, P0827.)

For many years, the "best show in town" was often the festivities at the annual Kankakee Inter State Fair. This summer 1930 image shows leading elements of that year's livestock parade just arriving at the fair's grandstand. The fair's grand marshals are seen on horseback, followed by an area school's marching band. At the rear of the band is a cavalry troop of the Illinois National Guard, wearing OD shirts, garrison caps and pink riding breeches. Kankakee native Len Small, governor of Illinois from 1921 to 1929, was a fervent supporter of the Kankakee Fair. (KCMPC, P1462A.)

One of the major employers in the Kankakee area was the Kankakee State Hospital. This c. 1930 photograph shows the facility's distinctive clock tower, built in 1883 under the direction of local contractor James Lillie. The first patient was admitted in December 1879 to what was originally known as the Illinois Eastern Hospital for the Insane. Maintaining 18 main building wards, 20 cottage wards, and 52 other buildings, by the beginning of the 20th century, the hospital complex was the second largest mental health facility in the United States. It was renamed the Kankakee State Hospital in 1910. (KCMPC, P6267.)

These nine nurses were photographed on the snow-covered steps of one of the Kankakee State Hospital's detached cottage wards sometime in the winter of 1931. Regarded then as innovative, some patients at the hospital were assigned to cottage settings based on the nature of their mental disease and on their ability to function independently. Standing at left in the middle row is Elizabeth Irene Barnard. Her sister, Bonnie Bird Barnard, stands at right in the bottom row. In 1932, Bonnie married Everett Andrews, a sales representative in Kankakee for the International Harvester Company. (KCMPC, P6268.)

At the Kankakee State Hospital it was important that the patients be kept active. Group activities were organized to give the residents a sense of purpose. In addition, it was found that encouraging patients to perform various tasks together generally exerted a calming effect. In the 1929 image at top, male patients are exercised together under the direction of a male staff member, supervised by a hospital nurse. In the bottom 1931 image, female patients are shown gathered together in the day room of one of the hospital's main building wards. These patients would have been more dysfunctional than those living in cottage wards. Interestingly for this period, there are two African American patients appearing in the group photograph. (KCMPC, P 6271 and P6272.)

These two formal portraits were made in 1929. At top is Dr. David Creighton, the reverend of Kankakee's First Presbyterian Church, located on North Indiana Avenue. Dr. Creighton came to Kankakee in 1907 from Chicago's Christ Church. He would remain in Kankakee for the next 24 years, ministering to the area's Presbyterian community until 1931. The Presbyterian church was established in Kankakee by 1854, with construction on the new church commencing in 1880. At bottom is Dr. Creighton's wife, Bertha Chatfield Creighton. (KCMPC, P1438 and P1437.)

Building construction continued in Kankakee during the early years of the Great Depression. Frank Leslie Shidler owned and operated a road construction business in Kankakee from 1916, called the Shidler Construction Material Company. The Shidler family is shown here in this 1931 image, standing at the entrance to Frank Shidler's home, located on Kankakee's South Wildwood Avenue. They are, from left to right, Anna Norris Shilder, Leslie Louis Shidler, Louis Pahnke, Doris Shidler, Frank Leslie Shidler, and Frank's wife Bertha Shidler. Sitting at center is an unidentified member of the Shidler household. (KCMPC, P9015.)

At the beginning of the Great Depression, the farming community was already in dire straights, having suffered nearly a decade of falling prices. Local government tried to help, offering scientific farming advice through organizations like the Kankakee County Soil and Crop Improvement Association. This 1930 photograph shows one of the association's representatives discussing farm matters with one of his clients. Former governor of Illinois, Kankakee native Len Small, was the president of the association. Governor Small had a life-long interest in area agriculture. The association's offices were located on North Schuyler Avenue. (KCMPC, P4466.)

69

The Great Depression, precipitated by the crash of the New York Stock Exchange in October 1929, came as a tremendous shock to the American people. These two photographs, along with the two on the opposite page, illustrate the attempt of Kankakee area businessmen to help themselves by jump-starting Kankakee's economy. Their plan was to give away $1,500 divided into 25 cash awards to encourage shoppers to return to Kankakee's stores. The top image shows the crowd gathered in Kankakee's Court Street on February 24, 1932, waiting to hear the announcement of the winner's names. The bottom image, also taken on Wednesday, February 24, 1932, shows the winners in Kankakee's first Prosperity Monthly Sales Day, holding their checks. (KCMPC, P9150A and P9150D.)

The top photograph depicts the crowd waiting in the middle of Court Street on March 30, 1932, to hear who would receive the 25 cash awards in Kankakee's second Prosperity Monthly Sales Day. The award announcement during the last Prosperity Monthly Sales Day is seen in the bottom photograph taken on May 7, 1932. The failure of the project is symbolized by the hand-written sign, "Going Out of Business," hung over the Klassy Shoppe that appears at the left center of the image. (KCMPC, P9150C and P9150B.)

71

Securing a white-collar job was very difficult during the Great Depression. These 1933 graduates of Kankakee's Gallagher School look rather grim as they face an uncertain future. They are gathered on the steps of the Kankakee Court House, where they have gone seeking jobs as court recorders and court clerks. The Gallagher School, located on Kankakee's Indiana Avenue, owned and operated by Mary Margaret Gallagher, offered "Accounting, Stenography, Typing and Complete Business Training." (KCMPC, P9403.)

These four gentlemen are shown in 1931, posed with their automobiles, which were used to deliver copies of the Kankakee *Daily Republican* to area newsboys. The *Daily Republican*, edited by Leslie Small, the son of former Gov. Len Small, was a fairly conservative paper. It suggested the Depression was only temporary and that things would ultimately turn out all right. For too many people, the nation's downward economic spiral seemed to have no end. (KCMPC, P8845.)

The Republican Party faced difficult challenges in the presidential election of 1932. Whether it was fair or not, many people associated the Great Depression and general economic failure with the Republicans. Kankakee native Len Small, who had won the Illinois gubernatorial race in 1920 and 1924 and having sat out the term between 1929 and 1933, was the Republican candidate for governor again in 1932. At top is a photograph of a window advertisement for Small's 1932 effort that appeared in Kankakee stores. It emphasizes the all-weather highways built during his previous administrations and attempts to distance him from President Hoover's stand on the bonus issue. At bottom is a photograph of Small's election parade that visited all the communities in Kankakee County on Election Day 1932. Small was defeated in his 1932 attempt to regain the governor's chair. He died in 1936. (KCMPC, P4644 and P2740.)

The Democratic candidate Franklin Delano Roosevelt won the presidency in 1932. In his inaugural address he asserted, "The only thing we have to fear is fear itself, nameless, unreasoning, unjustified terror." He spoke to the common man, who put great faith in his administration's New Deal. Working men believed FDR, such as these employees of the Kankakee Foundry Company, located on Station Street in West Kankakee. These men were photographed in 1933. (KCMPC, P3590.)

This photograph of the Truman Huling home, located on Kankakee's South Dearborn Avenue, was taken in the winter of 1932–1933. It seems to epitomize the time right after Roosevelt's election and before the effect of his initial New Deal programs were felt. Note the sign over the woman's shoulder advertising for "roomers."(KCMPC, P1173.)

At the height of the Great Depression some families could only manage to feed their children once a day. Some children only received a hot meal at school. These students at the Taylor School, photographed in 1931 with their teacher Florence Moran Wainwright, may not have been so fortunate. (KCMPC, P3729.)

The one-room Taylor School House was built in 1904. Members of all eight primary grades studied together inside the building that was located in Rockville Township, near the village of DeSelm, in northeastern Kankakee County. The school operated in this fashion until 1954. It did not have electricity or a heating system until 1948. Florence Voss is shown here, photographed at the school's front door in May 1935. The Taylor School House was moved to the Kankakee County Museum complex in 1976, where today it is restored as a memorial to rural educators like Florence Voss. (KCMPC, P3732.)

Family and friends weathered the Great Depression together. This group portrait of the Kankakee Grange of Friends was taken in 1933. They are, from left to right (first row) Margaret Kelly, Alice Kelly, Catherine Strutzel, and Isabella Regnier; (second row) Clo "Cutie" Fortier, Geneveive Ladd, Remilla Kelly, Laura Cote, and "Buster" Fortier. Alice Kelly was a stenographer for the Lehigh Stone Company and Catherine Strutzel helped her husband Frank sell soft drinks. Laura Cote was a stenographer at Kankakee's First Trust and Savings Bank and Remilla Kelly was a saleswoman at Kankakee's Chicago Store. (KCMPC, P9218.)

Despite the hardship, still there is an air of romance associated with the 1930s. That continued spirit is embodied by this charming portrait of Juanita Owen Pontious made in 1933 and inscribed simply "your Juanita." She worked as a cashier at the Hotel Kankakee, while her husband Harold Pontious was a draftsman for Edwin Pratt's Sons, located on Kankakee's Greenwood Avenue. (KCMPC, P6050.)

Five
1935 to 1939
The Great Depression: "People Are Managing to Survive This Thing"

As the economy improved in the late 1930s, the "swing music," played by numerous dance bands across the country, rose in popularity. This 1936 image shows the "Kankakee Dance Band," posed against a painted backdrop. Harry Yeates, the band's leader (second from left) is shown with his banjo. The other identified band members are Ray Wulffe on trumpet (fourth from left), Albert Sellers on saxophone (sixth from left), and his brother Delbert Sellers on clarinet (seventh from left). (KCMPC, P0765.)

This is a 1935 photograph of the Kankakee County Court House, which had its corner stone laid in 1909. It opened in 1912. The gentleman standing in the foreground is Frank Chapman, who sold real estate in Kankakee County. He and his wife Nellie lived on Evergreen Avenue. The real estate business had been difficult during the first years of the Depression, but things were getting better for the Chapmans. (KCMPC, P0778.)

As economic conditions got better, people began using their automobiles again for pleasure driving. The first drive-in filling station in Kankakee, located at the corner of Court Street and West Avenue, is seen here in this 1935 image. Within the year, the Baron Huot Oil Company had two other filling stations in Kankakee, one on West River Street and the other on Washington Avenue. Gasoline was selling for 18¢ a gallon. (KCMPC, P2806.)

Rural families still needed to find ways to supplement their income. Fannie Still offered "special dinners and suppers daily" from her home on Station Street. She encouraged customers to visit her table with this advertisement placed in her window. Fannie also fed her five feline friends, one of which appears in this 1935 photograph. Fannie owned a farm outside Kankakee and was at one time Gov. Len Small's private secretary. (KCMPC, P3775.)

These two young women were members of Kankakee's working class community in the mid-1930s. At left is a 1935 image of Jeanette Demere, whose father Leon Demere was a foreman at the Florence Stove Company. Jeanette Demere lived with her parents at South May Avenue in West Kankakee, until she died suddenly in her twenties. At right is a 1936 image of Lottie Hanny Quigley, who came to Kankakee from Marseilles, Illinois in 1928. She worked for the Bernstein, Cohen and Company Overall Factory. (KCMPC, P0182 and P3393.)

These children were photographed in 1935, just after they helped box up for shipment a portion of a rhubarb field's harvest. Rhubarb, or "Pie Plant," was an important crop in the area. This large rhubarb field was located between State Route 113 and Butz Road, a position currently occupied by the Riverside Health Care complex. The sealed boxes are labeled "Fancy Pie Plant." (KCMPC, P8565.)

Some Kankakee citizens developed innovative businesses. Louis and Sarah Schleichardt created Slyhart's Bakery. Their seven female bakers operated 24 hours a day and served 80 Kankakee area grocery stores and restaurants. In this 1937 posed photograph, one of Slyhart's delivery girls is shown bringing a tray of baked goods to a customer in the Riverside district. (KCMPC, P8508).

The automobile fleet of another Kankakee business is seen in this 1935 image. The Domestic Laundry Company, owned by Alfred Eugene Anderson, was located on Kankakee's North Dearborn Avenue. The 10 white delivery trucks shown would pick up your dirty laundry and return it cleaned, pressed, and packaged. An advertisement of the Domestic Laundry Company declared that their "knowledge of colors, fabrics and cleaning methods is your protection." (KCMPC, P9362.)

The wedding cake might have been provided by Slyhart's and the linen for the reception might have been brought by the Domestic Laundry Company to the Beland/King marriage in 1938. The bride (at center) is Margaret King, who worked as domestic help for the Ashner family. Her groom is Harvey Beland, who worked as a factory hand and upholsterer for Kroehler Manufacturing Company. Bridesmaid Bertha Beland, the groom's sister, is seen at far left, and at far right is the groom's brother, Hector Beland, who is acting as usher. The identity of the second bridesmaid is unknown. (KCMPC, P8571.)

People might ignore the Great Depression, if only temporarily, by attending romantic films and listening to exciting dance bands. Shown here in these 1936 publicity stills is Donald Bestor, who was the leader of a well-known Chicago area orchestra. This Kankakee native led his band in performances on NBC and other radio stations from the late 1920s and throughout the 1930s. (KCMPC, P2968 and P2969.)

Dance bands, such as that led by "Dr. Don" Bestor, frequently played for college dances. This photograph of the lovely young ladies of Lamba Sigma Alpha, a local college sorority chapter, was taken in Kankakee on June 18, 1938. The dance was apparently being held, as was the custom then, in the upstairs main room of the Kankakee National Guard Armory. (KCMPC, P6160.)

These two young women in their evening gowns illustrate the romance often associated with the Depression decade. At left, in a 1935 image, is Wanda Osienglewski, whose parents Joseph and Mary "Dottie" Osienglewski operated a saloon on Indiana Avenue. At right in a 1934 image is Edna Birr, who in 1935 worked as a stenographer for the Kankakee Chamber of Commerce. (KCMPC, P4758 and P4759.)

The employees of the Kankakee Firestone Auto Supply and Service Store, located on the corner of Merchant Street and Indiana Avenue, are seen here in this 1937 image. Firestone offered automobile radios with complete installation for $39, along with free batteries for their drive-in customers. Everyone wanted a radio set with clear reception in their cars, many of which came from the factory without an "audio-radio." At extreme left stands mechanic Robert LaBeau, and at far right is his brother, salesman Art LeBeau. Standing second from right is salesman Clarence Bergeron. (KCMPC, P9175.)

The postal workers employed by the United States government at the Kankakee Post Office gathered together for this group portrait made in 1939. Dressed in their "Sunday best," these mail carriers, clerks, postal agents, and members of the custodial crew are assembled at the post office's front door. Standing in the first row, second from left, is postmaster George Ravens. Next to him, third from left, is his supervisor, superintendent of the mails Scott Hollister. (KCMPC, P8502.)

More than occasionally, the famous and the influential visited Kankakee during the mid-1930s. On November 6, 1935, well-known aviatrix Amelia Earhart spoke at a luncheon held in the Kankakee Armory, sponsored by the Business and Professional Woman's Club of Kankakee. After her formal remarks, someone asked her why she liked to fly and she replied, "There is no reason except my wish to do so. I believe every woman should strive for a goal outside what is platitudinously known as her sphere." Amelia Earhart is at the center of this 1935 image. At left is Mary Gallagher and Louise Mercier, both area nurses. At right is Elizabeth Mann (a widow) and Fannie Still, secretary at the Small family farm. (KCMPC, P5804.)

The U.S. Postal Service had been moving mail by air since 1918, although in 1934 it ceased general supervision of air routes and awarded air contracts to small aviation firms. Kankakee County area postmasters and postmistresses are seen here gathered at the Kankakee airport in 1938, celebrating a new airmail route between Kankakee and points south. Standing in front of a small plane and aircraft hanger are, from left to right, Helen McCarthy of Bradley, Mrs. Guest of Reddick, Mary Schosser of Essex, George Ravens of Kankakee, three unidentified men, Zepher Duschene of Kankakee (assistant), Frank Kerieg of Manteno, Frank Laking of Grant Park, Amos Westphal of Herscher, Leo Desens of Union Hill, unidentified, Oscar Stehr of Bonfield, and two unidentified men. (KCMPC, P5358.)

The employees of the Kankakee Nehi Bottling Company and their families are seen here gathered for a group photograph taken in 1935. Their annual summer picnic was held at Kankakee River State Park. They worked at the Nehi facility located on Kankakee's Fifth Avenue. "Take a good look at the bottle," declares their sign. (KCMPC, P5540.)

Kankakee was fortunate to be the home of two fine hospitals. For the period, both the Riverside Medical Complex and St. Mary's Hospital were considered to be very well-equipped. Standing at left is registered nurse Lillian Wasser. Nursing sister Virginia stands at center behind the machine, while nurse Katherine Fonger assumes the patient's position, demonstrating the X-Ray equipment at St. Mary's Hospital on May 12, 1938. (KCMPC, P4059.)

The Mann family is seen here in the backyard of their home on South Greenwood Avenue, gathered for a family photograph on Easter Sunday, April 17, 1938. Arthur Mann, who was superintendent of the Paramount Textile Company, stands in back. In front, from left to right, are his daughters Peggy and Mona, his wife Mona, and daughter Rhonda. (KCMPC, P1518.)

Allan Bergner and Harry Stella played together on the Kankakee High School football team in 1934, and eventually played against each other in an Army-Navy game. Bergner attended the United States Naval Academy and was named captain of the Navy football team in November 1938. Stella attended the United States Military Academy at West Point, New York, and was named captain of the Army squad in 1938. This photograph shows them receiving presentation watches on December 27, 1938, at a banquet held for them in Kankakee. Stella and Bergner led their respective teams against each other in the annual Army/Navy game on December 2, 1939. Hundreds of their home town friends gathered in the Kankakee Armory to listen to the game on radio. Navy won with a score of 10–0. (KCMPC, P5817.)

The stunningly beautiful Dorothy "Dottie" Osienglewski Turk appears in this fine 1938 portrait wrapped in her exquisite brand-new fur coat. Although doubtlessly wearing it for style and glamour in this image, she was going to need it for warmth in the winter of 1938–1939. Her husband, Joseph Turk, was the president of Turk Furniture Company, located on Kankakee's North Schuyler Avenue. (KCMPC, P4757.)

This unidentified gentleman is seen walking down the south side of the 200 block of Kankakee's East Court Street in late January 1939. It is the beginning of a major snow storm that will shortly blanket the area. Two women can be seen at center, just to the right of the lamppost crossing the street with their fur collars turned up against the rapidly falling snow mixed with sleet. (KCMPC, P8439.)

These two photographs show the after effect of the massive snow storm that hit the Kankakee area in late January 1939. Both images were taken on January 30, 1939. At top is a view of Merchant Street looking west. The Illinois Central's Passenger Depot Building is at the center of the picture. The streets have not yet been cleared, but at left a delivery truck belonging to National Food Stores is being unloaded. At bottom is the alley between Indiana and Dearborn Avenues, with a rather gleeful looking group towing out a stranded City of Kankakee police cruiser. (KCMPC, P4076 and P4064.)

89

The Illinois National Guard Armory Building, shown here (left) in this 1939 image, was located on Kankakee's North Indiana Avenue. Its architecture combines the Art Deco style popular in the 1930s with the government style commonly found in Federal buildings of this period. Its main function was to serve as headquarters for Headquarters Company and for Company L, both elements of 3rd Battalion/129th Infantry (Illinois National Guard). At bottom, some of the men of Headquarters Company, 3rd Battalion/129th Infantry are seen in this photograph taken on August 18, 1932, at Camp Lincoln, near Springfield, where they attended their annual summer maneuvers. The officers standing at left wearing "Sam Browne" Belts are, from left to right, Major Goodyear, Captain Blandy, and 1st Lieutenant Morgan. (KCMPC, P4737 and P7896.)

90

These two images are views of the Kankakee men who drilled at the Armory Building during the 1930s. At top are soldiers of Headquarters Company, 3rd Battalion/129th Infantry taking their authorized 10 minute rest break alongside the road during their summer maneuvers in 1935. The bottom image is a formal company portrait of Company L, 3rd Battalion/129th Infantry taken at their Electric Park monthly encampment held in Kankakee. This photograph was taken in August 1938. The officers, seated in the middle of the second row are, from left to right, Capt. Jasper T. Burns (lawyer), 1st Lt. Roy F. Dusenbury (postmaster) and 2nd Lt. Vincent C. Nickerson (student). During World War II many of these men would fight their way across the South Pacific, from Guadalcanal to the invasion of Luzon, in the Philippine Islands. (KCMPC, P2679 and P1835.)

The citizens of Kankakee managed to survive the Great Depression with both determination and dignity. This attitude seems well exemplified by the fine 1939 portrait shot appearing at left of Fannie Still. She worked as a secretary at the Small family farm in Kankakee. At right is a portrait of Dorothy Spohrer Fedde. Her husband, Dr. Harding Fedde, was an optician maintaining his office on Kankakee's East Court Street. (KCMPC, P3763 and P3909.)

The romance and, indeed, the civility associated with the 1930s, both shown graphically in the films of the period, can be seen here as well in this group photograph of a dinner party held in Kankakee in 1939. It took place in the home of William Erzinger, who operated Erzinger Pure Food Stores, which was the largest independent grocery business in Illinois. The ladies are, from left to right, Norma St. Germain Taylor, Lois Wertz Diamond, Anna Norris Shidler, Ruth Funk Roth, Aglae Gernon Butz, and William Erzinger's daughter, Isabel Erzinger Tolson. The gentlemen are, from left to right, Leslie Louis Shidler, Judge Irwin Taylor, Noel Diamond, Joseph Tolson, Vernon Butz, and Waldo Roth. (KCMPC, P8708.)

Six

1940 to 1945
Kankakee and World War II: "Everyone Wants to Do Their Part"

America entered World War II on December 7, 1941, with the Japanese surprise attack on Pearl Harbor, Hawaii. The coming of the Second World War, however, had been felt in the nation and in Kankakee County for several years. In 1938, the federal government started defense preparations, which meant more jobs in armament production. In the late summer of 1940 the United States War Department inaugurated the first large-scale peacetime draft in American history. Over 6,000 of Kankakee's young men received a year of military training under this program. Elements of the National Guard participated in large-scale corps-sized maneuvers in 1940. Kankakee's Company L, 3rd Battalion/129th Infantry departed in March 1941. What many people would remember about World War II was the general enthusiasm with which everyone wanted to do their part. In this fine portrait, Ensign William Cooper, U.S. Navy, displays his Errol Flynn–like good looks. Before the war, Cooper had been the manager of Kankakee's Florence Stove Company, located on West Station Street. (KCMPC, P6856.)

93

This photograph shows a part of Kankakee on the eve of World War II. Taken at Water Street, the photograph looks down Washington Avenue in July 1940. At least three bars, a lunchroom, a drug store, and two gas stations can be seen. As this photograph was taken 20 miles north of the city of Kankakee, the U.S. Army was just beginning construction on the Kankakee and Elmwood Ordinance Works. (KCMPC, P3411.)

The steady pace of pre-war life continued for a little while. Kankakee High School science teacher Jennie Webb sits at her desk in this image made in September 1940. Part of her current lecture, as is indicated by the text on the blackboard behind her, is about the nature and habits of the common housefly. (KCMPC, P9201.)

It may have seemed to many people that getting through the Great Depression represented a miracle. By 1940, the Roosevelt administration had managed to restore the nation's economic stability with a series of government programs known by a bewildering set of acronyms, that must have seemed to the average person rather like "pulling rabbits out of hats." In this photograph, Kankakee entertainer Edward Reno performs a magic trick on stage in October 1940. He and his wife Minnie lived on Kankakee's South Greenwood Avenue. His occupation in the 1939 Kankakee City Directory is listed as magician. "It is a great thing to have fun at your work," he wrote, "particularly if you can convince people to pay you for it." (KCMPC, P1092.)

Some held more prosaic employment. Leroy Dandurand drove a horse-drawn cart for Meadow Gold Dairy. He also worked for the Beatrice Creamery Company, selling Meadow Gold ice-cream on Kankakee's West Avenue. This portrait of Dandurand, wearing his working clothes was made in the spring of 1941. (KCMPC, P5655.)

Le Beau's Body Shop located on North Schuyler Avenue and East Station Street is pictured on June 9, 1940. In the summer of 1940, Paul Le Beau's automobile painting, body and fender repair service was a relatively new member of Kankakee's business community. He is proudly displaying his new wrecker. At left can be seen the store front of Corn Belt Frozen Foods, advertising among other things, boiled ham at 27¢ a pound. Zephire Marquis managed Corn Belt, which represented the future of consumer goods, for in 1940 frozen food was still a novelty. (KCMPC, P9600.)

Members of Kankakee's working class are illustrated in this 1940 photograph taken on the floor of the Florence Stove Company located on Station Street in West Kankakee. They are welding gas-stove frames. This work shift contains two female members, which is interesting for 1940. The workers are, from left to right, George Toune, Edna Cheffer, Frank Holmes, Hector Charbonneau, Eugene Smith, James Lucht, Anthony Offenbecker, Eva Jefferson, Clifford "Hungry" Walters, and Charles Montgomery. (KCMPC, P9117.)

These two images were taken during the 1940 Christmas season. The wintry Kankakee scene at top was used as a postcard. The building in the center is the First Methodist Episcopal Church, located on South Harrison Avenue. It was subsequently renamed the Asbury United Methodist Church. In the bottom photograph, Dr. Anson Nickerson is shown holding a sheet of Christmas seal stamps and the associated poster meant to encourage people to buy them during the 1940 Christmas season. The money raised was intended to help fund tuberculosis research. (KCMPC, P1735 and P3956.)

97

By the summer of 1941, the appearance of military men in everyday life was becoming more pronounced. This 1941 photograph of a Kankakee wedding party is a case in point. The best man, standing at left, is Tech. Sgt. Donald Bolen, who is a non-commissioned officer in the regular U.S. Army. The leather waist belt on his class A uniform identifies the image as prewar since leather waist belts were no longer issued to enlisted personnel after Pearl Harbor to save leather. The bride and groom are Louise and Oscar Bolen. The maid of honor, standing between Sergeant Bolen and the bride, is Rose Beauchamp. (KCMPC, P0500.)

After Pearl Harbor and America's entrance in World War II, uniforms became a much more common sight. By February 1942, members of the military were required by regulation to be in uniform at all times, even at home on furlough. Throughout the war, trains moved troops through Kankakee, so the sight of soldiers and sailors, a prewar rarity, became commonplace. This fine portrait photograph, taken on August 26, 1942, shows two recently commissioned infantry officers. They are Lt. Paul Homer Dupuis (left) and Lt. Frederick Cachilli (right), both Kankakee natives who had been members of the Illinois National Guard and who had left with Company L, 3rd Battalion/129th Infantry for training in March 1941. Subsequently, they attended officer's candidate school at Fort Benning, Georgia. (KCMPC, P6896.)

Young men and women answered the nation's call without hesitation to participate in the great crusade against tyranny known as World War II. All through the conflict they were enthusiastically supported on the home front. Immediately after Pear Harbor, the U.S. Marines were swamped with volunteers, as the Marines (then a purely voluntary force) had a reputation for toughness and for being the "first to fight." Handsome Kankakee native Sgt. John Gorman is seen here in this 1942 portrait photograph, epitomizing the image of the rugged Marine "non-com." (KCMPC, P7016.)

This interesting image of Capt. Murray Frazier was made on April 15, 1942. Frazier was photographed in the early part of World War II at a time when American forces were conducting a protracted, but ultimately doomed defense of the Bataan Peninsula in the Philippine Islands. Captain Frazier commands a company of the 129th Infantry (Illinois National Guard). He is wearing a white dress shirt with his class A blouse and a Sam Browne belt, along with an officer's whistle inside his left top pocket. These are all prewar items. His pencil thin mustache was common in the period, and considered extremely dashing. After the end of World War II he elected to remain in the army. (KCMPC, P6980.)

99

Aviation was still new enough to retain its air of romance and adventure. Many eager young men joined the army air corps and all of them wanted to be hot pilots. Wearing his new wings, Lt. Herbert Field is seen here at an air corps training facility on October 23, 1942. He is joined by his parents, Alfred and Georgia Field. Alfred Field was a printer and the Fields lived on Kankakee's South Evergreen Avenue. Behind them is an A-7 Texas Trainer used to instruct potential fighter pilots during the second phase of their training. "Bless the instructors who taught us to fly, they're sure surprised that we're still alive." (KCMPC, P6989.)

In the army air corps during World War II, pilots, co-pilots, navigators, and bombardiers were commissioned officers. The remainder of flight crew, air gunners, radiomen, and other technicians were always enlisted personnel. These Kankakee twins served as aircrew during the war. They are Norman (left) and Jack (right) DeWitt. Their widowed mother, Della DeWitt, worked as an attendant at the Kankakee State Hospital. (KCMPC, P6926.)

There were many jokes about the youth and cockiness of air corps pilots in World War II and this 1943 image seems to justify them. They emphasized this spirit by removing the wire stiffener from their officer's garrison hats to give it a more rakish appearance creating what was known as the "officer's crush." Kankakee native Lt. William Beckhelm Jr. has done that and is wearing his "crush" in this photograph. His father, William Beckhelm Sr., was a mail carrier living on South Harrison Avenue with his wife Jessie. (KCMPC, P6765.)

In the course of World War II ordinary men found themselves in extraordinary circumstances. These two late war images, from about 1945, show two of them. At left is David Brown, Gunner's Mate Third, U.S. Navy. At right is Sgt. Joseph Dominick. His shoulder patch is the insignia of the 65th Infantry Division, which did not enter combat operations until March 1945. Sergeant Dominick and his comrades crossed the Rhine River and participated in the final Allied drive across Germany. (KCMPC, P6683 and P6933.)

World War II was fought on the home front as well. American patriotism was often expressed in scrap metal collection drives. In this 1943 image five Kankakee Great War veterans are seen participating in an aluminum collection. Aluminum was an important element in aircraft production. On their truck, under the name American Legion (a World War I veteran's association) appears the numerals 40/8. This is a reference to French railroad freight cars that could carry 40 men, or eight horses. (Kankakee County Photographic Collection, P3583.)

An electric automobile owned and driven by Ida Moore Small in the 1920s is seen here in this 1943 photograph. Now it is another contribution to a wartime scrap-metal drive. Ida Small was the wife of Len Small, governor of Illinois from 1921 to 1929. On page 42, she can be seen standing with her car in an earlier photograph. The festive atmosphere that often accompanied wartime scrap-metal drives is well captured in this particular image. (KCMPC, P3390.)

During the war, enthusiasm for scrap-metal collecting sometimes got the better of good judgement. In 1897, the U.S. Army, at the request of the Kankakee chapter of the GAR, donated two seacoast heavy Parrott rifled guns for placement on the Kankakee Court House square. In this December 18, 1942, photograph, from left to right, Asaph Clemans, David Blatt, and Delmer Bailey are seen helping to scrap these two artillery pieces for inclusion in a wartime scrap-metal drive. Removing such museum quality pieces was useless, as the metal used in their construction was unusable for war production needs. Their removal did, however, result in the destruction of fine examples of mid-19th-century artillery production methods. David Blatt managed his family business, the Kankakee-based Blatt Iron and Coal Company. Delmer Bailey was one of his foremen and Asaph Clemans one of his workers. (KCMPC, P4084.)

Doing duty as a Civil Defense Air Raid Warden provided another avenue for civilian participation in the war effort. This 1944 image shows the award-winning Civil Defense drill team fielded by Kankakee's auxiliary firemen. Kneeling at left center is their team leader Donald Schneider, who worked as a clerk at his father's insurance company. Kneeling at right center is Herman Kline, chief of the Kankakee Auxiliary Fire Service. He owned a woman's clothing store located on East Court Street. (KCMPC, P1443.)

During World War II, large numbers of women took advantage of new opportunities for national wartime service. In the initial months of the war, Army Chief of Staff Gen. George Catlett Marshall became a great champion for the establishment of the Women's Army Corps, intended to give American women a place to perform necessary active duties and release large numbers of men for more active combat roles. This excellent portrait photograph was taken on March 1, 1943, of newly commissioned Lt. Thelma Copenhaver. Lieutenant Copenhaver was a prewar resident of Kankakee County. (KCMPC, P6857.)

Officers and enlisted personnel of the WAC performed clerical, quartermaster, and even ordinance duties in the U.S. and overseas throughout World War II. This is a 1943 photograph of Elizabeth Gamble of Kankakee. She joined the WAC as a private on December 2, 1944. (KCMPC, P7022.)

Perhaps rather more traditionally, women served during World War II in the Army Medical Corps, which had begun commissioning female nurse officers in the 1930s. In 1940, Dorothy Lonergan was a nurse working in Kankakee. After Pearl Harbor, she joined the Army Medical Corps as a nurse lieutenant. She is shown here in this portrait taken on July 27, 1945, very near the end of the Second World War. The wings over her metal ribbon bars indicate that she was assigned as a flight nurse. After the war, she resumed working as a nurse in Kankakee, and married Dr. Henry Hartman, who practiced medicine in the county. (KCMPC, P7380.)

Soldiers, sailors, marines, airmen, and coastguardsmen from Kankakee served across the world during World War II. Taken in February 1945, this photograph shows part of the crew of an LST (Landing Ship Tank) manned by US Coast Guard personnel, all of whom were from Illinois. This particular LST was present during operations against the Japanese stronghold on Okinawa, where the American fleet was subjected to massive Kamikaze attack. In the first row (third from left) kneels Wilbur Cash of Kankakee. After the war he married his girl Helen and opened a Shell Gasoline Station in his hometown. (KCMPC, P6861.)

105

This studio portrait image was made in 1944. Seaman Wesley Hayhurst of Kankakee posed wearing his blues. After the war, he returned to Kankakee County and found employment as an assembler for Kroehler Manufacturing Company. He made furniture that was much in demand due to a postwar housing boom fueled by the return of his fellow veterans. (KCMPC, P1230.)

Toward the end of World War II, a strained war-weariness can be seen in the photographs of these combat veterans. At left is U.S. Petty Officer William Bowers, a machinist photographed on October 15, 1943, wearing his newly awarded Purple Heart. His service ribbons indicate much active service. At right is S.Sgt. David Brown, who served with the Eighth Air Force as a gunner in a heavy bombardment squadron. Already wearing decorations, in this 1944 photograph he is seen just after being awarded the Distinguished Flying Cross, which was the second highest decoration available to enlisted personnel. (KCMPC, P6745 and P6701.)

During World War II, Americans fought for a variety of reasons, such as to defend America and democratic-style institutions, to halt the spread of fascism, and to end tyranny. Images of home became more important as an individual's overseas duty lengthened. American military personnel decorated their lockers, barracks, and even their aircraft with depictions of the girl back home. This 1943 portrait of the beautiful Jane Huber Smith, a Kankakee native, is representative of the images of home that Kankakee servicemen took with them around the world. (KCMPC, P1099.)

This image perhaps best typifies the brash, somewhat cocky generation that fought World War II to a successful conclusion. This is a 1944 photograph of Lt. W. K. "Kenny" Giroux, who was a pilot in the army air corps. Returning to Kankakee County following his military service, Lieutenant Giroux opened a tavern in Bradley, "Carl & Kenny's." (KCMPC, P7039.)

The U.S. Navy named one of its support vessels after the Kankakee River. The United States naval oiler *Kankakee* is seen here posing for her portrait in this April 1945 photograph. She is returning to the west coast after participation in the naval war in the Pacific, where she earned six battle stars for serving with the fleet during the assaults on Palau, Yap, Ulithi, and Woleai atolls; in the Marianas and Philippine Campaigns and in the reduction of Iwo Jima and Okinawa. The *Kankakee* served on into the Korean Conflict and during the Cuban Missile Crisis. She was decommissioned in July 1968. (KCMPC, P4044.)

The end of World War II in Europe came with the formal surrender of the German government on May 7, 1945. There was general relief when Japan surrendered following the atomic bombing of her cities and the Russian invasion of her Manchurian territory. This photograph, taken on August 14, 1945, shows a spontaneous demonstration in the middle of Kankakee's Court Street celebrating V-J Day, or victory over Japan. (KCMPC, P4276.)

Seven
1946 TO 1953
THE IMMEDIATE POSTWAR PERIOD: "A NEW ORDER OF THINGS PREVAIL"

A year after the end of World War II, the nation was slowly readjusting its economy to consumer production. Veterans were slowly re-entering the work force. Although there was much anxiety about the spread of Communism and the awful destructive power of atomic weapons, most people simply wanted to return to the pace of prewar America. Taken on May 30, 1946, this photograph depicts Kankakee's Merchant Street looking toward the Illinois Central's Passenger Depot Building. The 16-car fleet of the combined Red Top and Yellow Cab taxi companies are seen parked together along Merchant Street. Getting a meal on Merchant Street would not have been a problem, as it housed the Coney Island Hotel Restaurant, along with Myrt and Dave's place serving "home cooking," and Illinois Valley Ice Cream. (KCMPC, P5390.)

The production of private automobiles had virtually ceased during World War II and as a consequence, the first thing many returning veterans wanted was to purchase a brand new car. Demand was so high that impatient purchasers endured long waiting lists. In the top 1946 photograph, Steven Richard (left) is seen receiving the keys to his newly purchased "46" Hudson from Victor Edward McBroom (center) while Wendell Frerichs (right), attending the event, looks straight at the camera. Richard bought the first Hudson automobile sold in postwar Kankakee. McBroom and Frerichs operated Jeffers and McBroom Hudson and Cadillac Sales on Kankakee's Main Street. In the bottom 1951 photograph prospective buyers are shown inspecting the 1951 Hudson "Hornet" at the Jeffers and McBroom showroom, when more normal sales conditions prevailed. (KCMPC, P5752 and 5762.)

People in Kankakee hoped commercial aviation would result in dynamic economic growth for the city. In the top photograph, taken on November 20, 1947, the owners and operators of the Kankakee airport are seen with the largest aircraft to ever land in the field. In the immediate postwar world, aviation would soon be turned to other purposes than business growth. The U.S. government helped win the peace in Europe with the Marshall Plan. In the bottom photograph, taken on February 28, 1946, workers are seen loading cartons of donated clothing for shipment to war-ravaged Europe. Supervising the workers at right is Fannie Still, who was the chairperson of the Kankakee County Overseas Relief Association. (KCMPC, P4093 and P3773.)

Feeding America, as well as maintaining food shipments to other distressed nations sustained agriculture in Kankakee in the years following the war. Christopher Brandt was a tenant farmer in Kankakee, working the farmland owned by Mr. and Mrs. W. D. Robertson. He is seen here in this 1949 image astride a tractor working one of his employer's cornfields. (KCMPC, P4003.)

Everyone experienced some hard times in the years following World War II. There was, for example, a nation-wide coal miner strike in 1950. The last four weeks of the strike took place during severe winter weather. The available coal supply was rationed. Taken in February 1950, this photograph shows a woman receiving the coal she was allowed to purchase from employees of Kankakee's Florence Stove Company, located on West Station Street. (KCMPC, P3248.)

Gladiolus production became an important cash crop in the postwar years. Kankakee County became well-known for these charming flowers. These members of the Illinois Gladiolus Growers Association were photographed near the Kankakee County village of St. Anne in February 1950. They are in the process of loading over 1 million gladiolus bulbs. It was the largest shipment made in a single day ever recorded. (KCMPC, P3252.)

Growing gladiolus in Kankakee County became such an important component of area agriculture that annual countywide festivals celebrated the arrival of the blooming flowers. These were typically held toward the end of August. Joan Peterson was the 1949 Momence Gladiolus Festival Queen. She was photographed in August 1949 standing in a gladiolus field and holding an impromptu bouquet. (KCMPC, P3354.)

In the early 1950s, most middle-class Americans had a very definite perception of female beauty. These two images of Kankakee women seem to personify that ideal. The top photograph of Patricia Lowe appeared in the society page of a local newspaper. She had just been selected Miss Kankakee for 1949. The magazine she is holding is dated May of that year and is open to an article titled "Fraternity Month." The bottom photograph is the wonderful *c.* 1950 wedding portrait of Marion Wicklander, who is shortly to become Mrs. Kenneth Larson. (KCMPC, P3353 and P3953.)

Not all women were content to resume traditional roles. This was certainly true of the Martin Sisters, who delighted Kankakee audiences from 1934 to 1954 with their travel reviews. Their lectures describing their trips around the world were enlivened with song and dance. They offered shows like: "Wings Over the Tropics," "African Safari," and "From Kankakee to Cairo." Here the twin sisters are seen in this 1946 publicity still doing a step from the "Blueberry Dance," part of their presentation on Eskimo life in Alaska. Lula Martin is on the left and Mable Martin is on the right. Lula was a mathematics teacher at Kankakee High School, while Mable taught English at Chebanse High School. (KCMPC, P6171.)

Some women found useful and fulfilling roles in community service. These African-American women worked for the Kankakee Chapter of the American Red Cross. Following a dinner meeting in 1950 they assembled for their photograph. They are, from left to right (first row) Viola Lamb, Inez Polk, Hattie Stalwell, Evelyn Holden, Partia Mae McKee, Juanita Hicks, Helen Price, Vera Lee Lamb, and Sara Turner; (second row) Martha Pointer, Queenie Ruth Nickerson, Evelyn Pointer, Daisey Lackey, Ruth Woods Anderson, Lula White, Nellie Jackson, Ida Tall Anderson, and (standing) Queenie Nailon. The two nurses and the other woman standing in the back of the group are unidentified. (KCMPC, P6344.)

Organized in December 1906, the Kankakee County Historical Society is one of the oldest historical societies in Illinois. It began displaying artifacts and documents in the Kankakee High School in 1912 and after 1936 did so in the Kankakee County courthouse. In 1945, the Illinois state legislature appropriated funds to create a memorial to Kankakee native Gov. Lennington Small. At the same time, the Small family donated 25 acres of land and the historic Dr. A. L. Small House for the proposed museum. These two photographs were taken on October 17, 1948, dedication day at the new Small Memorial Park. The top image shows the Dr. A. L. Small House at right. The bottom image shows the crowd waiting to see the exhibits in the new museum building. Since 1948 there has been considerable expansion and today the Kankakee County Museum contains eight large galleries with permanent and temporary exhibits. It also maintains the Dr. Small House (1855) and the Taylor School, a one-room rural school house built in 1904 and moved to the museum complex in 1976. (KCMPC, P0060 and P0056.)

Kankakee has always been proud of its history. Establishing a museum dedicated to preserving the rich history of Kankakee County was considered a big event. That public spirit is illustrated in this photograph taken from a tall building looking down Kankakee's Court Street. It is a view of the parade held on October 17, 1948, celebrating the creation of Small Memorial Park and the Kankakee Museum. Containing covered wagons, horse-drawn vehicles, bands, and representatives of civic organizations, the parade started at the museum's location on Eighth Avenue and Water Street. (KCMPC, P0421.)

The Kankakee Valley Park District has long supported a series of events and programs designed to educate Kankakee youth. The Park District intensified their efforts in the immediate postwar period. In the summer of 1949, training and preliminary bouts for the Kankakee Junior Police boxing program were held in various Kankakee parks for grammar school–aged children. This 1949 image shows some of the young contenders who participated in the program on the grounds of Small Memorial Park at the site of the present Kankakee County Museum. The main event was held at Bird's Park on Friday, July 29, 1949. (KCMPC, P9590.)

The postwar period saw the creation of many Kankakee cultural institutions. The Kankakee Symphony Orchestra was founded in 1948. Their conductor, Eldon Basney, is seen in the top image, displaying his rather intense attitude during a rehearsal for part of the 1949 season. The bottom 1949 image shows the bass violin section of Basney's 60-piece orchestra. The Kankakee Valley Symphony Orchestra continues to provide outstanding classical music to the Kankakee area. (KCMPC, P3338 and P3339.)

The Kankakee Art League, established in 1946, is another Kankakee area cultural organization that was founded in the immediate postwar period. This is a 1948 photograph of a drawing class sponsored by the Kankakee Art League being held inside the new quarters of the Kankakee County Historical Society. The students are sketching the young lady at left, with her back to the camera. The instructor standing at center is Arthur Wunderlich, whose day job was manager of the State Employment Service, located on Kankakee's South Osborn Avenue. Today at the beginning of the 21st century the Kankakee County Museum continues this tradition of supporting the arts and other cultural organizations in Kankakee County. (KCMPC, P3344.)

Kankakee has been the home of a number of artists, both amateur and professional, such as the very talented Joseph Campbell, appearing here in this 1953 photograph. Campbell was well known for his drawings and paintings of local historic structures. He is posed with a just-completed sketch of the splendid Hotel Riverview, which opened for business in July 1887. The magnificent vision of Victorian opulence was destroyed by fire in November 1897. Campbell's sketch of the Hotel Riverview was intended for inclusion in the centennial edition of the Kankakee *Daily Journal*. (KCMPC, P8676.)

Political candidates often passed through Kankakee, pausing only long enough to make whistle-stop speeches from the back of their railroad cars. At left, Illinois native son Adlai Stevenson, the 1952 Democratic Party presidential candidate and Illinois governor, is seen addressing a Kankakee crowd at the Illinois Central's Passenger Depot in October 1952. He was defeated by Republican Party candidate Gen. Dwight David Eisenhower, and defeated again in 1956. At bottom California Sen. Richard Milhous Nixon is seen, also in October 1952, making remarks from his train car in Kankakee, rebutting Senator Stevenson. Senator Nixon was General Eisenhower's running mate in 1952 and 1956. (KCMPC, P4111 and P8328.)

The appearance of political figures like Stevenson and Nixon in Kankakee was duly reported by the hard-working news staff at the Kankakee *Daily Journal*. Established in 1853, the *Daily Journal* remains the largest and most important newspaper in the county. At top is a 1951 image showing part of the *Daily Journal's* newsroom. Breaking wire news came over the printers seen at right and was taken by reporters, who used manual typewriters to turn out their copy. The gentleman in the left foreground is Herbert Jannusch, sports editor for the *Daily Journal*. At bottom is a 1950 photograph of the 100 block of Kankakee's East Avenue, Kankakee's lively business district, where everyone read the *Daily Journal*. (KCMPC, P4410 and P1248.)

These two photographs taken in May 1953 provide some interior views of the Pepsi-Cola bottling plant located on Routes 45 and 52, south of the main Kankakee business district. The Pepsi presence became an important element of Kankakee's postwar economy. From the upper left center to the right of the first image much of the entire bottling process is illustrated. The bottom image shows cartons of Pepsi being loaded onto a delivery truck. The Pepsi-Cola formula was originally invented around 1880 by a former Confederate army officer, living in the coastal region of North Carolina. (KCMPC, P4112 and P4114.)

Some of Pepsi's products from their Kankakee bottling plant were probably delivered to restaurants right in Kankakee, for example, to the Steak 'N Shake located on Kankakee's North Schuyler Avenue. The Steak 'N Shake lunch counter is seen here in this photograph taken in July 1950. A "deluxe" hamburger complete with French fries could be purchased for 67¢, while a milkshake was only a quarter. (KCMPC, P4104.)

There were many establishments in Kankakee where one could get something stronger than a soft drink. In 1952, there were 56 taverns in Kankakee, with another 16 located in the adjacent towns of Bradley and Bourbonnais. Those bars offering Budweiser probably received their stock from Bydalek Brothers, local beer distributors. This 1952 photograph shows their warehouse facility located on the 500 block of Kankakee's South East Avenue, along with their fleet of delivery trucks. The building appearing at left was one of the oldest buildings in Kankakee. It originally housed an antebellum linseed oil factory, which operated there at the beginning of the Civil War in 1861. The old Bear Brand hosiery factory is partially seen back right. (KCMPC, P9248.)

In 1949, when these two photographs were taken, Kankakee boasted two large hotels, the Hotel Lafayette on Schuyler Avenue and the Hotel Kankakee on Merchant Street. There were seven smaller hotels in the city. The imposing front of the Hotel Kankakee appears in the top image. The Hotel Kankakee offered 150 air-conditioned rooms, which was rather an innovation in the late 1940s. One of their advertisements that boasted the "Kankakee" was, "host to the most!" Sadly the Hotel Kankakee is no longer extent. The bottom image shows the interior of the Hotel Kankakee's main lobby. The Hotel Kankakee offered private dining rooms, a lounge, banquet facilities, and a coffee shop, whose entrance can be seen in the upper right center of the bottom photograph. (KCMPC, P1218 and P1215.)

One of Kankakee's most venerable institutions was the First Trust and Savings Bank, located on Schuyler Avenue. Constructed in 1904, the First Trust and Savings Bank Building is seen here in this 1949 image. Its dynamic facade was dominated by the four large pillars shown, which were meant to symbolize the financial strength and solidarity of the bank. Signs in the upper windows can be seen advertising the bank's willingness to make loans, and issue insurance, or bonds. The First Trust and Savings was flanked by two of Kankakee's most important retail establishments, the Ward Department Store and the Sears, Roebuck and Company outlet. The First Trust and Savings Bank building was demolished in the 1960s. The columns and capitals were saved. Today they are part of the Kankakee County Museum's artifact collection. (KCMPC, P6240.)

Part of the community served by the First Trust and Savings can be seen in this 1950 image. It is a view of Schuyler Avenue looking north. The Hotel Lafayette can be seen to the left. At right the Luna Theater is offering two films, *Sabu, the End of the River* and *Unfaithfully Yours*. Just beyond the Luna can be seen the Hotel Kankakee. Although at this time Kankakee's streets were still paved with original cobblestone, the obvious presence of so many automobiles meant that charm would soon be replaced with utilitarian black asphalt. (KCMPC, P5530.)

Kankakee County was established in February 1853 and the City of Kankakee was incorporated the following May. In 1953, Kankakee proudly celebrated its centennial with a year-long observation filled with special events and programs. During these occasions, many people tried to dress in what they imagined to be the dress of the antebellum era. It became fashionable in 1953 for men to grow beards and other facial hair they thought appropriate for the centennial. These are the employees of the Kankakee office of the U.S. Postal Service, photographed in 1953. (KCMPC, P8484.)

The ladies got into the spirit of the centennial as well. These three participants in a period-style show are seen posing with a late-19th-century hearse owned by Clancy Funeral Home, located on Kankakee's South Harrison Avenue. They are, from left to right, Joyce Blanke, the rather coy Caroline Mortell, and Cindy Huot. (KCMPC, P2252.)

A sense of community spirit is often maintained by keeping a thorough appreciation of its past apparent and available. This has been the mission of the Kankakee County Historical Society since 1906. It continues to be the mission of the Kankakee County Museum into the 21st century. The past is all around us. It only requires a certain type of perception to see it. Taken during the 1953 centennial observation, this evocative image of an unidentified young woman is seen here, dressed in the style of the early 20th century. She was photographed in the formal dining room of the historic Dr. A. L. Small House (constructed in 1855) and maintained as part of the Kankakee County Museum complex. The rather "dreamy air" she is affecting has been wonderfully captured by the camera. This image seems a fitting end to this collective view of Kankakee's second 50 years. (KCMPC, P2858.)

On June 21, 1953, the City of Kankakee celebrated its heritage and centennial with the massive Kankakee Centennial Parade. For Kankakee's citizenry it was an opportunity to express pride in their community, by both honoring the past and demonstrating their confidence in the future. The top image shows the head of the parade column, led by the marching band, majorettes, and twirlers of the Kankakee High School, photographed at East Court Street across from the Kankakee County Courthouse square. In the bottom image, the marching column contains the Kankakee Boy Scout Troop and Kankakee Girl Scouts, with a gathering of nurses from Kankakee area hospitals, St. Mary's, the Kankakee State Hospital, and the Manteno State Hospital, behind them. (KCMPC, P9327D and P9327J.)